Robert Rauschenberg

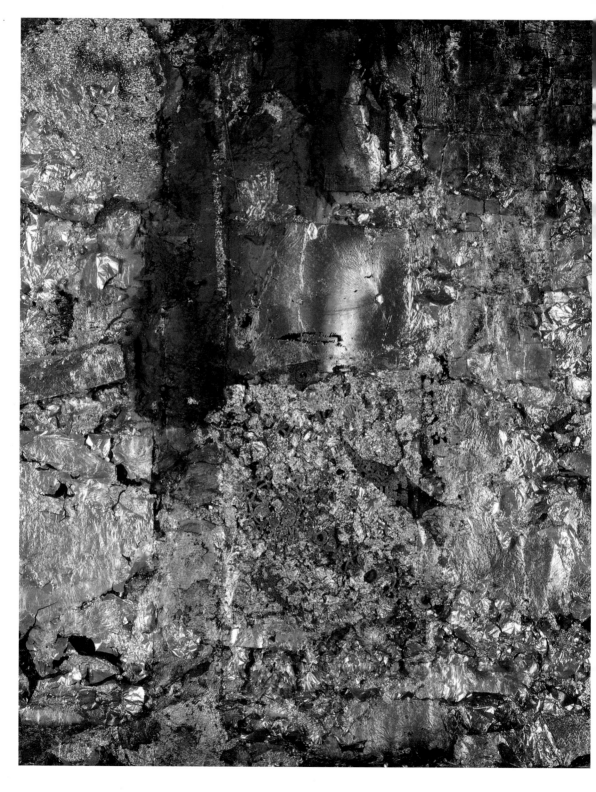

Robert Rauschenberg

Ed Krčma

Tate Introductions
Tate Publishing

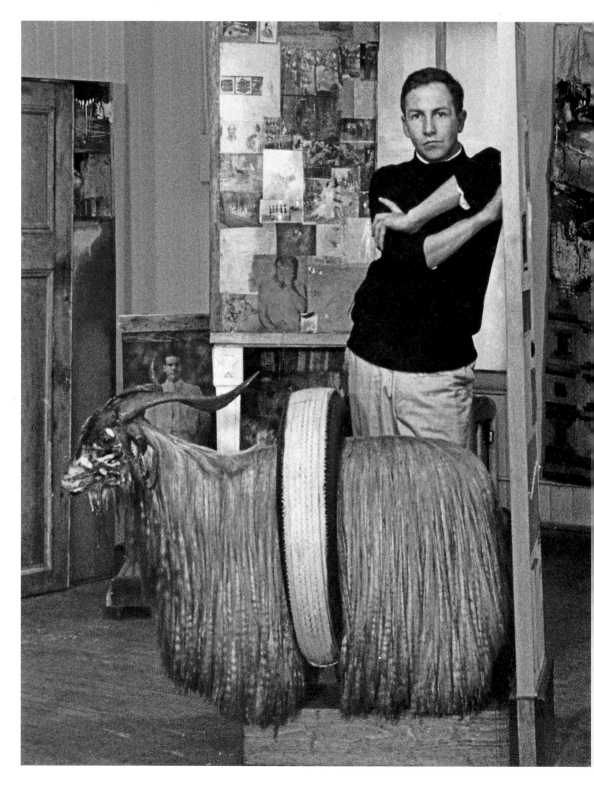

Any incentive to paint is as good as any other. There is no poor subject … Painting relates to both art and life. Neither can be made. (I try to act in that gap between the two.)[1]

I don't want a painting to be just an expression of my personality. I feel it ought to be much better than that … I've always felt as though, whatever I've used and whatever I've done, the method was always closer to a *collaboration* with materials than to any kind of conscious manipulation and control.[2]

Jasper Johns once asserted that Robert Rauschenberg had 'invented more than any artist since Picasso.'[3] Not only did he work across a formidable range of media throughout his long career – including painting, sculpture, drawing, collage, assemblage, photography, silkscreen, lithography, performance, set design, and installation – but Rauschenberg also invented new categories and techniques of his own. Most famously he referred to the seminal works that he began making in 1954, which married the languages of painting, sculpture, and collage, as 'Combines' (fig.1). Rauschenberg became famous not only for crossing boundaries between media, however, but also for transgressing conventional hierarchies of aesthetic value, and a crucial part of his contribution was to establish new ways for art to make contact with the energy and contingency of everyday life. In this he helped enable an important transition from the sublime scale, gestural intensity and fraught pathos of abstract expressionism, with its frequent rejections of mass culture, to the brash, appropriated and apparently superficial surfaces of pop art, which emerged in the early 1960s in the United States (and a few years earlier in Britain).

Rauschenberg's achievement is poorly represented as a mere stepping-stone in art's wider development, however. Prizing experimental energy over the maintenance of stable criteria for judging aesthetic quality, and engaging in creative collaborations

of diverse kinds, Rauschenberg was consistently motivated by a drive to extend art's formal, technological and inter-cultural possibilities. Central to his practice was the conviction that the artwork's significance should not be limited to the specific intentions or personal feelings of the artist: 'What interests me is a contact,' he declared in 1961, 'it is not to express a message.'[4] For Rauschenberg, art should demand more from the viewer than recognition and understanding, instead serving to complicate and intensify perception, keeping our mental habits limber and dynamic. Frequently employing irreverent and sometimes iconoclastic tactics, especially in the 1950s, his work presents open arrays of signs and materials that both compel immediate attention and maintain the vivacity of that encounter, after any initial jolt has receded.

From Port Arthur to Black Mountain

Rauschenberg was born on 22 October 1925 in Port Arthur, Texas (in 1947 he changed his name from Milton to 'Bob,' which then became Robert). His father, Ernest, the son of an immigrant Berlin doctor and a Cherokee woman, worked for a local power company; his mother, Dora, was deeply religious and the family attended the austere Church of Christ.[5] Severely dyslexic at a time before the

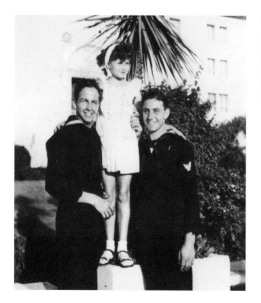

2. Rauschenberg, his sister Janet, and a friend from the Navy, San Diego Naval Repair Base c.1944 Robert Rauschenberg Foundation Archives, New York

condition was widely understood, Rauschenberg had a hard time at school. He nevertheless graduated in 1942 and later enrolled on a pharmacology course at the University of Texas, although he lasted little more than six months there. In 1944 he was drafted into the U.S. Navy and ended up working as a neuropsychiatric technician in San Diego (fig.2).

By Rauschenberg's own account the idea of being an artist simply did not exist in the environment of his childhood, and his first visit to an art museum came when he saw pictures by Thomas Gainsborough and Thomas Lawrence at the Huntington in San Marino. It was a revelation, he later said. Having received honorable discharge from the Navy in the summer of 1945 he then travelled, working briefly as an illustrator in Los Angeles. In 1947 he enrolled in the Kansas City Art Institute on the GI Bill, saving money to study in Paris and entering the Académie Julian the following year, where he met fellow American student Susan Weil. Disappointed by the atmosphere of the course, Rauschenberg and Weil spent most of their time together, visiting museums and painting experimentally but without much focus.

Returning to the U.S. in autumn 1948, Rauschenberg and Weil enrolled at Black Mountain College, a liberal arts institution situated in a rural location near Asheville, North Carolina. Founded in 1933, Black Mountain employed a diverse faculty, with courses enhanced by the contributions of an impressive roster of visiting teachers, which had recently included the architect Buckminster Fuller, composer John Cage, choreographer Merce Cunningham, and painters Elaine and Willem de Kooning. Rauschenberg had been attracted to the college by the reputation of Josef Albers, the Bauhaus master known for his rigorous and disciplined approach, but by his own account Rauschenberg was very far from being Albers's favourite pupil.

In late summer 1949, Rauschenberg moved with Weil to New York, where he enrolled at the Art Students League. At this time a powerful momentum was gathering behind the group of painters now known as the abstract expressionists, many of whom had cut their teeth on the New Deal arts projects of the 1930s. The years 1948–50 saw a wave of crucial exhibitions mounted by a small but concentrated network of private galleries, exhibitions that would launch the careers of such artists as Willem de Kooning, Jackson Pollock, Franz Kline and Barnett Newman. While it is dangerous to generalise, the loose

group was united in significant respects by a bold exploration of the language of abstract painting, working through the lessons of European modernism on a dramatically expanded scale. Some of the movement's champions emphasised the drama of the process of painting itself: against the powerful forces of social conformity in post-war America, the canvas became 'an arena in which to act,' to borrow Harold Rosenberg's famous phrase – an open field in which authentic and spontaneous acts of self-definition could take place (fig.3).[6] The results would be the product of an expressive intensity characterised by doubt and risk, the immersive pictures standing as powerful equivalents for the complex and chaotic depths of subjective experience. Other critics, Clement Greenberg chief among them, concentrated instead on the formal properties of the paintings themselves, and championed Pollock in particular for

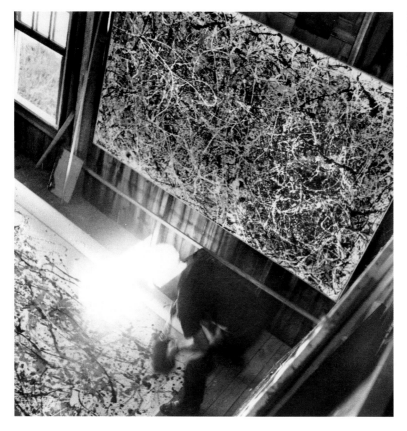

3. Hans Namuth
Jackson Pollock painting
One: Number 31 1950,
with *Number 1* 1949 on
the wall behind him.
Center for Creative
Photography, University
of Arizona

having trumped European modernism by combining the lessons of its major tendencies (principally, surrealism and cubism), in unified and aesthetically convincing syntheses.[7]

Rauschenberg would soon enter into sustained dialogue with abstract expressionism. At this point, however, he was working (with Weil, whom he married in June 1950) through the possibilities of photography – notably in a series of Blueprint works made by shining a light directly onto large sheets of photosensitive paper onto which objects and bodies had been laid (fig.21) – as well as collage and glyphic painterly forms (fig.23). Having approached the gallerist Betty Parsons for an opinion on his work, Rauschenberg was surprised when she offered him a solo exhibition, which opened in May 1951. The works he presented were small and somewhat delicate, and the exhibition elicited no more than a handful of brief, mild yet not unsympathetic reviews.

The 1950s: Polemical Impurity

That summer Rauschenberg returned to Black Mountain. He was joined briefly by Weil and their baby son Christopher, but the marriage was already dissolving and the couple were officially separated the following year. Rauschenberg threw himself into new experimental possibilities, the most radical of which was his series of *White Paintings* 1951 (fig.23), which consisted of modular canvases painted a pristine white. First viewed as extremist end-points within debates on abstraction, for Rauschenberg the *White Paintings* had less to do with negation than with allowing the picture to register the tiniest incident arriving from the external world. They would be like hyper-sensitive screens – 'airports for the lights, shadows and particles', as John Cage would write in 1961 – pictures that would have nothing to do with self-expression and everything to do with heightening the viewer's attention to the minute and contingent activity of the world usually passing beneath the threshold of perception.[8]

In the spring break of 1952, Rauschenberg travelled with Cy Twombly to the southern states and Cuba. Here he discovered a new method of drawing – solvent transfer – which combined his interest in newspaper and collage with a refusal of the idea of the graphic mark as expressive sign (fig.4). The method involved the soaking of mass media images in lighter fluid and rubbing them on their backs with

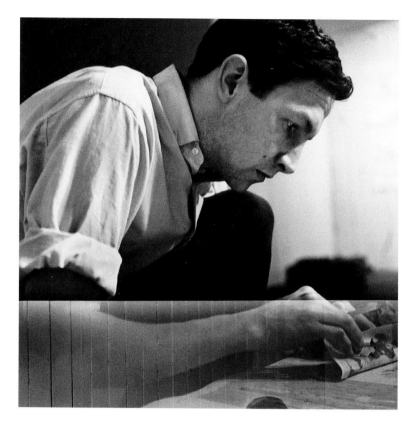

4. Jasper Johns
Rauschenberg working
on a solvent transfer
drawing in his Front Street
studio, New York, 1958
Robert Rauschenberg
Foundation Archives,
New York

an old ballpoint pen so as to transfer the ink from the printed source
to the drawn sheet below. The manual action was rudimentary and
repetitive, more like the work of erasure than that of creation.

In the autumn of that year the two young artists embarked on a
longer trip, this time to Europe (principally Italy) and North Africa,
where they explored the deep repository of European culture.[9]
Rauschenberg's production during this trip consisted largely of
photography, small collages, and a series of Joseph Cornell-like works
(fig.26). Consisting of salvaged fragments such as bones, beads, pins,
insects and found images, enshrined like secular votives or eccentric
relics, these latter constitute a kind of open visual poetry that called
on the viewer to construct associative links between their contents.

Rauschenberg returned to New York in April 1953. It is not known
whether he was in time to see de Kooning's notorious exhibition at
Sidney Janis Gallery, *Pictures on the Theme of the Woman*, but he

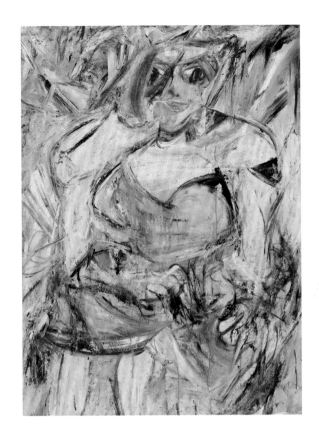

5. Willem de Kooning
(1904–97)
Woman II 1952
Oil paint on canvas
149.9 × 109.3
Museum of Modern
Art, New York

could not have been unaware of it (fig.5). Rauschenberg moved into a loft on downtown Fulton Street, and set to work developing the series of Black Paintings he had begun at Black Mountain in 1951 (fig.24), and extending his engagement with the monochrome in his 'Elemental Paintings'. The latter signalled a radical leveling of hierarchies: some works were made from gold leaf, others from the dirt on the studio floor, and each material held its own visual interest (figs.28, 29). Indeed, the polemical charge of Rauschenberg's early engagements with abstraction struck a nerve when he first exhibited them at the Stable Gallery in September 1953 (fig.6). The exhibition launched Rauschenberg's reputation as an *enfant terrible*. Artists and critics alike were affronted. Reviewing the show, Hubert Crehan, for example, exclaimed: 'White canvas, conceived as a work of art, is beyond the artistic pale. If anything, it is a *tour de force* in the domain of personality gesture.'[10]

6. Rauschenberg at *Rauschenberg: Paintings and Sculpture*, Stable Gallery, New York, Autumn 1953. Works shown, back to front, are *White Painting* [*Seven Panel*] 1951 and two untitled *Elemental Sculptures* 1953.

Sometime that autumn, however, Rauschenberg enacted his most direct and provocative engagement with abstract expressionism. The young artist had plucked up the courage to visit Willem de Kooning's studio with an unusual request. He asked the Dutch artist to collaborate in the making of a strange new work: de Kooning was to supply Rauschenberg with a drawing, which he then proposed to erase and exhibit as his own work. Understandably skeptical, de Kooning finally acquiesced, choosing a heavily worked sheet that he said he would 'miss.' It then took Rauschenberg weeks to erase it before the flecked, evacuated result was framed and given an inscription, 'Erased de Kooning Drawing, Robert Rauschenberg, 1953' (fig.7). While the work was barely exhibited until the 1970s, it has since become one of the most celebrated episodes in the so-called neo-avant-garde – understood as the revival of subversive artistic strategies, especially those associated with dada, in the 1950s and early 1960s.[11]

The symbolic connotations of this gesture again seem to be resolutely about negation: an iconoclastic gambit akin to Marcel Duchamp's defacement of the *Mona Lisa* in *L.H.O.O.Q.* 1919, or an act of Oedipal aggression against the reigning master. Rauschenberg, however, claimed no such intent, explaining to Calvin Tomkins in 1964 that 'It was nothing destructive. I un-wrote that drawing because I was

7. *Erased de Kooning
Drawing* 1953
Traces of drawing media
on paper with label
and gilded frame
64.1 × 55.3 × 1.3
San Francisco Museum
of Modern Art

trying to write one with the other end of the pencil… To use the eraser
as a drawing tool.'[12] As well as posing questions about the nature of
authorship, skill, and artistic creation as such, Rauschenberg was
clearly weighing his own artistic identity in relation to that of the
previous generation. While at a remove from the abrasiveness and
machismo that characterised the social atmosphere of the Cedar Bar,
where many of the New York School painters drank, Rauschenberg
later told Tomkins that in those days the challenge was 'to start every
day moving out from Pollock and de Kooning.'[13]

This dialogue would deepen and broaden as the 1950s wore
on. In late 1953, continuing his exploration of the monochrome,

Rauschenberg began to introduce more diverse and densely material contents into his pictures: fabrics, newspapers, and drips and smears of red oil paint, which had all the density of the action painter's mark but shared none of its willed expressive energy (fig.30). Soon the range of these materials broadened to include all manner of everyday detritus: items of clothing, photographs, old master reproductions, salvaged pieces of wood and metal, even light bulbs, radios and stuffed animals. Having purged the canvas of anything but 'lights, shadows, and particles', Rauschenberg began to let the world in again, and in it swept, pushing the picture more emphatically into three dimensions. Any material was deemed available for use: the 'gold' of the old masters rubbed up against the effluvia of the 'Funnies'; objects laden with connotations of privacy and domesticity took their place amidst the public culture of news media and urban signage; and paint that was driven and goaded by hand shared a space with readymade and collaged fragments in a resonant interchange of heterogeneous elements.

The early Combines, such as *Collection* and *Charlene* (both 1954) (fig.8), had about them the look of the attic clear-out. Objects eloquent of age and use – old shirts, swathes of fabric, and fragments of worn pieces of furniture – found their way into dense agglomerations of paint marks and printed matter. Such early Combines were given their first major presentation in the winter of 1954, when Rauschenberg exhibited them at Charles Egan Gallery. The response was again overwhelmingly negative, *The New York Times* critic Stuart Preston pulling no punches: 'This exhibition is fun in its own way and there would be no point in taking it too seriously were it not absurdly symptomatic of the demon of novelty.'[14]

The next two years saw the Combines become airier, with intense clusters of visual incident distributed within more sparsely populated fields. A key work here was *Rebus* 1955 (fig.34), in which a frieze-like sequence of art reproductions, political posters, sports and science photography, comic strips, and dripping areas of oil paint is organised along a shuffled spectrum of paint swatches bisecting the picture horizontally. The upper and lower sections are more open, and the title tempts viewers into a game of decoding (a rebus is a picture puzzle in which a series of unrelated image fragments stand for words or parts of words and add up to a discrete linguistic solution). The appropriateness

and viability of such a 'decoding' of Rauschenberg's work has been the subject of considerable debate in the literature on the artist. While some scholars have argued that coherent sets of associations exist between his very diverse images and materials, signalling Rauschenberg's intention to communicate, others have regarded the Combines as precisely disruptive of any such stable meanings (one problem here is where one *stops* interpreting, and what one has to edit out in order for meaning to remain coherent).[15] A useful way to approach these open arrays, presenting seemingly casual yet precisely balanced plays of analogy and disjunction, might be neither to enforce nor to close off the particular patterns of association that arise. Rather, these works invite varyingly distracted and focused forms of attention, and the viewer might pause to dwell on some details while circulating in a more mobile way amongst others.[16]

One important impetus for exploring the question of a deliberately veiled authorial intention in Rauschenberg's work has arisen from

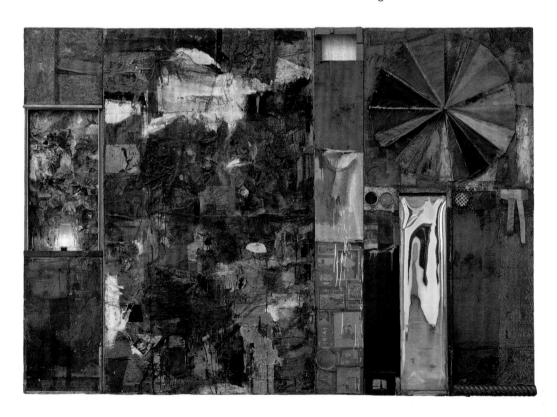

a concern with the artist's sexuality. Towards the end of 1953 he had met Jasper Johns, and by the following year the two artists had become a couple – they would finally separate during the summer of 1962 (fig.9). Indeed, critical commentary on Rauschenberg's work – overwhelmingly negative until about 1960 – was often tinged by homophobic allusions. In 1959 Hilton Kramer dismissed both Johns and Rauschenberg as symptomatic of a generalised 'breakdown in standards,' and criticised Rauschenberg's 'gaily contrived constructions [that] combine the official good taste of the most epigonous Abstract Expressionists with some decorative bits of nastiness intended to "offend".'[17] In a 1961 review, Jack Kroll would assert that in Rauschenberg's work, 'A poof of incense disperses the bracing pungency of the urban miasma … The rubber-spiked pitfall of Capotean indulgence, of *Harper's Bazaar* sensibility, gaggles menacingly before this art…'[18]

While such thinly veiled innuendos, combined with violent antipathy, speak of the repressive social conservatism of 1950s America, the inference of references to homosexuality in the Combines is not misplaced. Art historians such as Jonathan Katz have pointed to the way in which particular details – photographs of Judy Garland, suggestive clippings from comic strips, images of dapper gents, and imprints of body parts, for example – make indirect reference to gay argot and subcultural codes.[19] Others have seen in

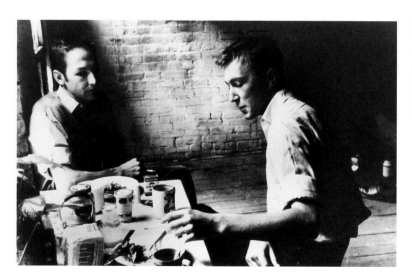

9. Rachel Rosenthal
Robert Rauschenberg
and Jasper Johns in
Johns's Pearl Street
Studio, New York, c.1954
Robert Rauschenberg
Foundation Archives,
New York

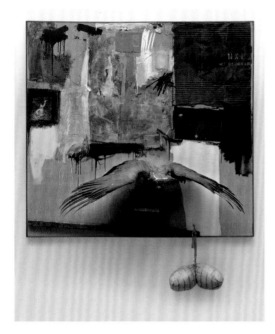

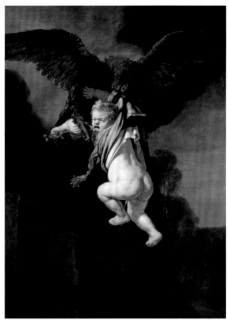

10. *Canyon* 1959
Oil paint, pencil, paper,
metal, photograph, fabric,
wood, canvas, buttons,
mirror, taxidermied eagle,
cardboard, pillow, paint
tube and other materials
207.6 × 177.8 × 61
Museum of Modern Art,
New York

11. Rembrandt van
Rijn (1606–69)
The Rape of Ganymede
1635
Oil paint on panel
177 × 130
Gemaldegalerie Dresden

Rauschenberg's decorative, domestic and even scatological materials the expression of non-normative and anti-heroic subjectivities.[20] Rauschenberg's iconic *Bed* 1955 (fig.33), for example, opens onto the intimacies of that space, while the equally emblematic *Monogram* 1955–9 (fig.37), in which a stuffed Angora goat is encircled by a car tire, has been interpreted as a potent if surreal erotic symbol.[21]

In a related vein, towards the end of the 1950s Rauschenberg addressed his new language to the repository of classical myths eloquent of same-sex desire. In 1959 he produced *Canyon* (fig.10). Here a taxidermied bald eagle springs from a cardboard box attached to the bottom of the canvas; elsewhere there is a photograph of an infant boy (in fact, Rauschenberg's son, Christopher) and images of astronomical constellations. Kenneth Bendiner has argued that the work makes explicit reference to the story of the Rape of Ganymede, via Rembrandt's famous 1635 rendition (fig.11).[22] Indeed, Rauschenberg would address the myth more directly that same year with his Combine sculpture, *Pail for Ganymede* 1959 (fig.41), with the suggestively slow rise of its gleaming metal cylinder and its penetrable cavity.

Such engagements with classical culture were spurred by the long labour of one of Rauschenberg's most widely celebrated projects: in the spring of 1958 he began making one drawing for each of the thirty-four cantos of Dante's *Inferno*, the first canticle of the great medieval epic *The Divine Comedy* (c. 1307–21).[23] Here Rauschenberg returned to the solvent transfer technique he had invented in 1952, making over the spatial conditions and narrative action of Dante's canonical poem (itself written in the vernacular Italian of Tuscany, rather than in the learned Latin), into the ephemeral imagery of the contemporary printed mass media (figs.12, 13). These transfers were then worked over with pencil and watercolour. Again, Rauschenberg had brought a canonical example of European culture into contact with the everyday language of contemporary American life, to enlivening effect for both. The illustrations were first exhibited in New York in December 1960, just weeks after their completion. Following their acquisition by the Museum of Modern Art in 1963, they were then sent on an extensive tour of European and other American venues. The drawings were picked out for special praise everywhere they went, often reversing skeptical assessments of Rauschenberg's work.

12. *Canto XXI: Circle Eight, Bolgia 5, The Grafters* 1960
From the series *Thirty-Four Illustrations for Dante's Inferno* 1959–60
Transfer drawing, gouache, cut and pasted paper, pencil, coloured pencil, wash on paper
36.7 × 29.2
Museum of Modern Art, New York

13. Police marching on pro-nationalist and anti-Rhodesian rioters wearing masks and carrying shields to protect themselves against rock-throwers
'Riot and Repression in Nyasaland', *Life*, 16 March 1959, p.43

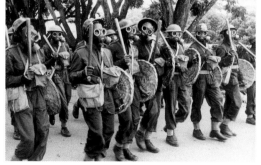

The 1960s: International Success and Restless Experiment

In 1962, following a visit to Andy Warhol's Factory, Rauschenberg adopted silkscreen as his chief method of making pictures. His re-engagement with the solvent transfer process had enabled him to incorporate photographic imagery into his drawings, although in this he was limited by the method's one-to-one scale.[24] Silkscreen enabled him to dramatically enlarge such transfers, mixing spectacular impact with a resistance to the kind of straightforward legibility common to advertising and news reporting. Prominent within his largely appropriated image repertoire were subjects of space age technology, cityscapes, sporting spectacles, old master paintings, and, in 1964, the iconic figure of the recently assassinated president, John F. Kennedy (fig.14). These reproductions were augmented by patches of oil paint, sometimes gesturally applied, which made the connection to the likes of de Kooning all the stronger. Such bold symbols of contemporary American life, with all its trauma and forward-leaning aspiration, soon became signature images of Rauschenberg himself, and icons of the global spread of American cultural influence more broadly.

14. Hans Namuth Rauschenberg working on the lower section of *Skyway* 1964. On the left, *Buffalo II* 1964, and on the right *Retroactive II* 1964
Center for Creative Photography, University of Arizona

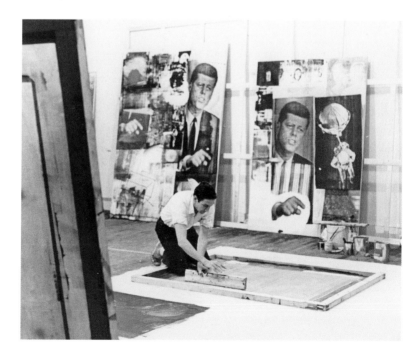

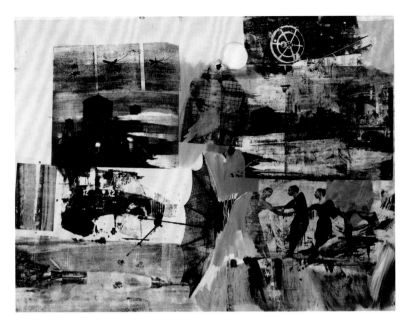

15. *Scanning* 1963
Oil paint and silkscreen ink
on canvas 141.6 × 185.4
San Francisco Museum
of Modern Art

In 1968 Leo Steinberg presented an influential reading of
Rauschenberg's work in a lecture aimed at unseating the dominance
of the modernist critical paradigm. Greenberg had privileged the idea
that advanced art should train itself – rigorously, relentlessly – on
the task of both specifying and purifying the nature of its medium.
For Greenberg, modernist painting had reduced pictorial language
to essentials – line, form, colour, and an all-over surface – in order
to produce aesthetically unified compositions that reaffirmed the
material flatness of the picture and enabled the undistracted roaming
of the enthralled eye. Steinberg instead stressed Rauschenberg's
radically impure language, which mixed abstract and representational
elements, opening pockets of space, and setting into relationship
all manner of different signs and materials (fig.15). Describing
Rauschenberg's 'flatbed picture plane' as a kind of 'post-modernist
painting,' Steinberg argued that his surfaces corresponded not to
the vertical axis of vision, but to the workings of the mind:

> [Rauschenberg's] picture plane … could look like some garbled
> conflation of controls system and cityscape, suggesting the
> ceaseless inflow of urban message, stimulus, and impediment

… Any flat documentary surface that tabulates information is a relevant analogue of his picture plane – radically different from the transparent projection plane with its optical correspondence to man's visual field. And it seemed at times that Rauschenberg's work surface stood for the mind itself – dump, reservoir, switching center, abundant with concrete references freely associated as in an internal monologue – the outward symbol of the mind as a running transformer of the external world, constantly ingesting incoming unprocessed data to be mapped in an overcharged field.[25]

Rauschenberg's star had been waxing gradually in the late 1950s. What followed, however, was a meteoric rise to international prominence. Following his inclusion in important group exhibitions, such as the influential *Sixteen Americans* show at MoMA and *Documenta 2*, Germany (both 1959), the crowning moments arrived in 1963 and 1964. The first saw Rauschenberg's major retrospective at the Jewish Museum, New York, an exhibition that drew increasingly ambitious and celebratory reviews from critics.[26] The second was Rauschenberg's win at the Venice Biennale (fig.16), a momentous and controversial event, which many Europeans viewed as a symptom of American cultural engineering and imperialism, but which nevertheless propelled the artist to the forefront of the international avant-garde.[27]

In the space of five years, then, Rauschenberg was catapulted from New York *enfant terrible* to international art world celebrity.

16. Ugo Mulas
Rauschenberg's *Express* being transported by boat to the Giardini grounds of XXXII Biennale Internazionale d'Arte, Venice, June 1964
Robert Rauschenberg Foundation Archives, New York

17. Douglas Jeffery
John Cage, Merce Cunningham, and Robert Rauschenberg, 1964
Victoria and Albert Museum, London

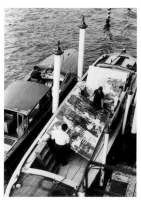
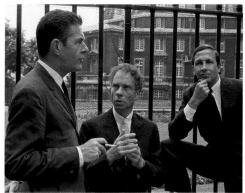

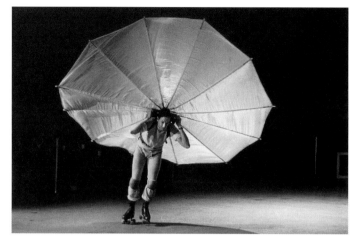

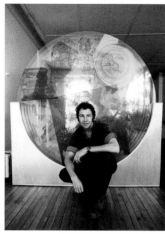

18. Peter Moore
Rauschenberg performing
Pelican 1965, First New
York Theater Rally

19. Maurice Hogenboom
Rauschenberg at his
Lafayette Street studio,
New York, with *Revolver
VI* c.1967
Robert Rauschenberg
Foundation Archives,
New York

Perhaps predictably his ability to deal with such rapid ascendency was mixed. He began to drink more (his capacity for Jack Daniels would become legendary) and his relationships with those artists and collaborators to whom he had been close became strained. Following Rauschenberg's triumph at Venice he continued on tour with the Merce Cunningham Dance Company, for whom he had been designing sets, costumes, and lighting since 1954 (fig.17). Between June and November 1964 they travelled throughout Europe and on to India, Thailand and Japan. On the road together for many months, operating under financial pressure and working to demanding deadlines in unfamiliar conditions, the tour took its toll, and by the time of the company's return to New York at the end of 1964 relations had cooled between Rauschenberg and Cage and Cunningham.

Following his return, and for the remainder of the 1960s, Rauschenberg nevertheless put most of his energies into performance work (his closest collaborations were with the Judson Dance Theatre) and experiments with technology. His first choreographed performance, *Pelican* 1963 (fig.18), was reprised at the First New York Theatre Rally in 1965 to an enthusiastic reception. In a review entitled, 'Daedalus at the Rollerdrome,' Erica Abeel enthused: 'Rauschenberg breaks down the distinction between the scenic element and the dancer, merging the two in a sort of locomotive human combine.'[28] *Map Room II* 1965 (fig.45) included moments at which Deborah Hay appeared wearing a wire mesh cage

containing three live white doves; Steve Paxton and Alex Hay moved cumbersomely across the stage, their feet planted inside car tires; and Rauschenberg himself appeared sporting foot-high platform boots and clutching a neon tube which was lit by a Tesla coil. As Branden Joseph has argued, Rauschenberg's performance works share affinities with those of Yvonne Rainer in their nonhierarchical composition and everyday, task-like movements. 'The components within Rauschenberg's performances', Joseph writes, 'are added, notas numbers or objects, but as vectors: their combination represents two or more forces that come together to produce a force with a different magnitude and direction.'[29]

Rauschenberg had long been interested in the integration of modern technology into his work (he had fixed concealed radios into *Broadcast* 1959 (fig.38), and *Oracle* 1962–5 (fig.46) for example), but throughout the second half of the 1960s he extended this concern into more formalised and demanding ways of working.[30] In September 1966 he co-founded, with engineers Billy Klüver, Fred Waldhauer and artist Robert Whitman, Experiments in Art and Technology (E.A.T.), which sought to promote and facilitate collaborations between artists and engineers. The aim of much of Rauschenberg's production was to enable his work to become more responsive to the presence and behavior of the viewer, installing various sensors and dynamic elements to enable the spectator/participant to influence its form. For example, the *Revolvers* 1967 (fig.19), were each comprised of five rotating Plexiglas discs, each mounted one behind the other and bearing silkscreened images. Viewers were able to rotate the discs using a control box, setting them into kaleidoscopic motion. Perhaps Rauschenberg's most ambitious technological project was *Mud Muse* 1968–71 (fig.47), a collaboration with the Teledyne Corporation, Los Angeles. A large vat filled with driller's mud would bubble and spurt in precise response to recorded sounds and those coming from the environment. This interactive element was first reduced in complexity and sometimes even eliminated altogether, however, indicating the difficulty of finding workable technological solutions to the artist's vaulting ambitions.

Rauschenberg would respond to the most dramatic of contemporary technological achievements in 1969, when he was

invited to witness the launch of the Apollo 11 space mission. Having become increasingly disillusioned with politics in response to the Vietnam conflict, amongst other things, Rauschenberg's experience of the moon landings restored to him some faith in the potential for progressive human advancement. Recalling his earlier solvent transfer drawings, the suite of 34 lithographs he made as a result (*Stoned Moon* 1969–70) (fig.48), the scale of which pushed the boundaries of what was possible in that medium, delivered an exhilarated and heroicising rendition of this extraordinary enterprise. A gloomier picture of the contemporary world, however, was presented by Rauschenberg's monumental *Currents* (fig.49), an enormous frieze of screen-printed extracts from contemporary newspapers detailing the horrors of Vietnam, the development of Cold War conflicts, the civil rights struggle, and many other fraught events dominating the media. In a 1971 exhibition announcement, he wrote:

> For over five years I have deliberately used every opportunity
> with my work to create a focus on world problems, local atrocities,
> and in some rare instances celebrate man's accomplishments…
> I have strained to bring about a more realistic relationship
> between artist, science, and business, in a world that is risking
> annihilation for the sake of a buck. It is impossible to have progress
> without conscience.[31]

The 1970s: Captiva

In 1968, enabled by his financial success over the past few years, Rauschenberg was able to purchase property on the small island of Captiva, Florida. Acquiring more land and buildings in the coming years, he established his main permanent residence there towards the end of 1970, while also maintaining his Manhattan studio. The move had a powerful effect on his work. The materials that now came to hand were of a different order, while the technical facilities he established enabled him to expand his practice in printmaking and other image transfer methods. Throughout the 1970s Rauschenberg would embark upon several series of discrete but related bodies of work, more materially spare than his Combines and often continuing the reproductive logic of his silkscreens, although now most often employing his own photography rather than that salvaged from

the contemporary media. Key aspects of his practice remained consistent, however, especially his commitment to using common, everyday materials and images.

The *Cardboard* series 1971–2 (fig.50) consisted of wall sculptures made with found cardboard boxes, the ultimate everyday object that was nevertheless loaded with connotations. As Yve-Alain Bois has argued, in art historical terms such boxes made reference to Warhol's emblematic pop art statement, *Brillo Boxes* 1964, to the repeatable units of minimalism, and to the 'poor' materials of arte povera. The *Cardboards* were in this respect also connected to Rauschenberg's Combines in their negotiation of pictorial abstraction and sculptural density; and the boxes themselves carried powerful if understated associations with an increasingly globalised economy, with company and product names signalling the networks of exchange and circulation of goods.[32] More mute and open than the declamatory atmosphere of *Currents*, the *Cardboards* returned Rauschenberg to a more formal and concentrated engagement with the contemporary object world.

Begun in 1975, the *Jammers* – of all his works perhaps the ones to court visual beauty in the most direct and unashamed way – were inspired in part by a trip made to India to collaborate with master paper makers there (figs.51, 52). These works consist of a spare vocabulary of hung fabric pinned and propped to the wall in elegant, colourful, and gently dynamic arrangements, the loose fabric swaying with the air currents. At the same time Rauschenberg was at work on his *Hoarfrost* series, in which he again used solvent transfer to print images on silk, satin and cotton fabrics (figs.53, 54). The title of the series derives from Dante's poetry, and indeed the series can be connected to the *Inferno* illustrations. As Rauschenberg explained to Tomkins:

> I was trying to figure out some way I could present images or their ghosts or their suggestions without constructing an object. So that what you're looking at could just as easily be part of your own memory, as presence … I thought of them as shimmering information. The material wasn't important – it was mostly cheesecloth, so fragile I'd have liked to draw on air if I could.[33]

Meanwhile, Rauschenberg had been asked by Walter Hopps to stage a major retrospective at the National Collection of Fine Arts (now Smithsonian American Art Museum), Washington, D.C., to mark the American bicentennial. The exhibition, which opened in October 1976, included 158 works and consolidated Rauschenberg's reputation as a contemporary American master.[34]

The 1980s and Beyond: Global Dialogues

Throughout the late 1970s, 1980s and beyond, Rauschenberg continued to experiment, on ever more ambitious scales, with image transfer processes of different kinds, and to make sculptural constructions from all manner of found materials. Again, these works arrived in series: *Spreads* 1975–82 (fig.55), *Gluts* 1986–9 (fig.57), and *Borealis* 1989–92 (fig.59), for example. Between 1984 and 1991, however, his central preoccupation was with a new project that sought to use art as a tool for the promotion of inter-cultural dialogue and world peace: the Rauschenberg Overseas Culture Interchange (ROCI). Entirely self-funded, this perhaps quixotic project involved Rauschenberg and his assistants travelling to countries either outside the dominant circuits of the rich Western art world, or home to populations living under repressive or nondemocratic regimes. Rauschenberg presented exhibitions in Mexico, Chile, Venezuela,

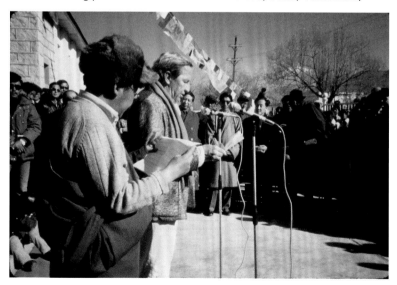

20. Rauschenberg and a Tibetan official at the opening ceremony for ROCI TIBET, Revolutionary Exhibition Hall, Lhasa, December 5, 1985
Robert Rauschenberg Foundation Archives, New York

China, Tibet, Japan, Cuba, the Soviet Union, East Germany, and Malaysia, making new work in response to each location and in dialogue with those he had met there (figs.20, 58). In 1991, works from each chapter of the programme were brought together for an exhibition held in Washington, D.C. While not Rauschenberg's most critically successful enterprise, ROCI is testament to the artist's enduring concern to engage in collaborative dialogue and to his faith in the power of art to contribute positively to human flourishing, opening his practice onto an increasingly globalised world.[35]

While his capacities were limited following the stroke he suffered in 2002, Rauschenberg continued to make art until the last years of his life. In October 2007 he began his series of *Lotus Paintings* (fig.60), which would be the basis of twelve prints published the following year by Universal Limited Art Editions, Rauschenberg's collaborator on print projects since 1962.[36]

Rauschenberg died of heart failure on 12 May 2008 at the age of 82. While his most decisive interventions in the history of modern art occurred in the 1950s and 1960s, the period that has been the focus of the majority of writing on the artist, there is still much work to be done in accounting for his later production. Much more than just a precursor to pop art, Rauschenberg's work between and across media, his engagements with new technologies, and his drive to engage the social, cultural and political conditions of an emergent globalised world all have powerful resonances for today.

21. Robert Rauschenberg
and Susan Weil
*Untitled [double
Rauschenberg]* c.1950
Monoprint: exposed
blueprint paper
209.6 × 92.1
Private collection

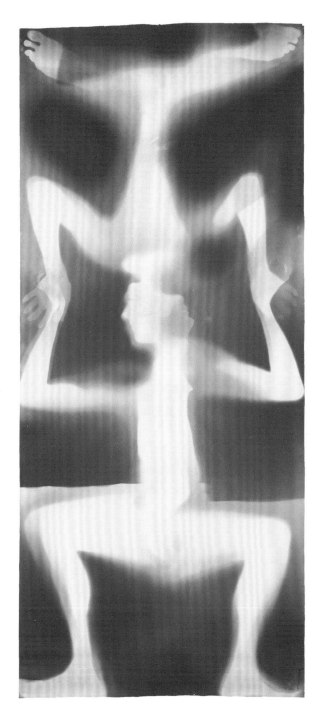

22. *22 The Lily White*
c.1950
Oil paint and pencil
on canvas
100.3 × 60.3
Collection of Nancy
Ganz Wright

23. *White Painting*
[seven panels] 1951
Oil paint on canvas
182.9 × 317.5
Robert Rauschenberg
Foundation

24. *Untitled* c.1951
Enamel paint and
paper on canvas
Four parts
221.1× 433.1
Whitney Museum of
American Art, New York

25. *Untitled (Mirror)*
1952 Transfer drawing,
oil paint, watercolour,
crayon, pencil, and cut-
and-pasted paper
26.7 × 21.6
Museum of Modern Art,
New York

26. *Untitled* (*Scatole Personali* series) c.1952
Lidded stained wood box
with dirt, pins, gelatin
silver photograph,
plastic lens and mica
3.8 × 5.4 × 7.6
Sonnabend Collection
and Antonio Homem

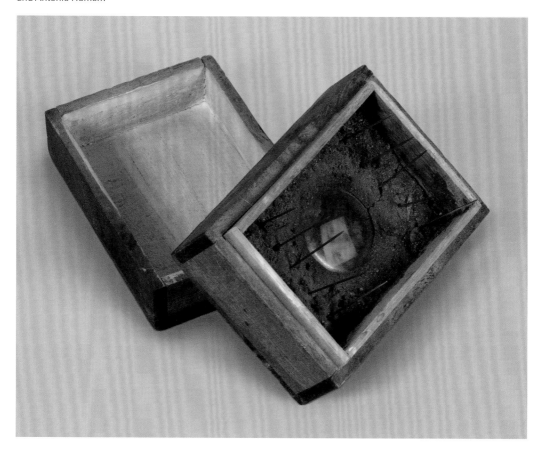

27. *Cy + Roman Steps*
(I–V) 1952
Suite of five gelatin silver
prints on paper
50.8 × 40.6 each
San Francisco Museum
of Modern Art

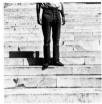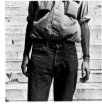

28. *Untitled (Gold Painting)*
c.1953
Gold and silver leaf on fabric,
newspaper, paint, wood,
paper, glue, and nails on
wood in wood and glass
frame, 26.6 × 29.2 × 3.5
Robert Rauschenberg
Foundation

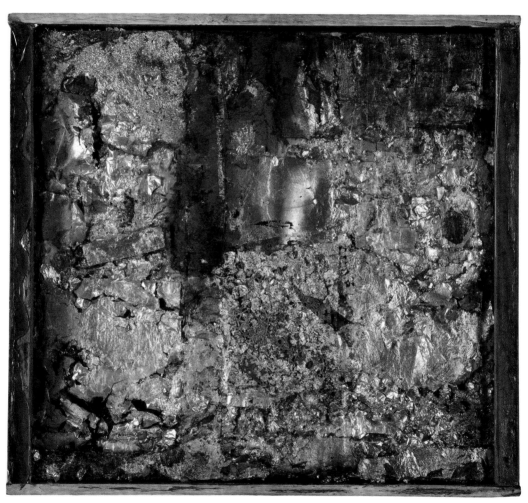

29. *Dirt Painting*
(For John Cage) c.1953
Dirt and mould in wood
box, 39.4 × 40.6 × 6.4
Robert Rauschenberg
Foundation

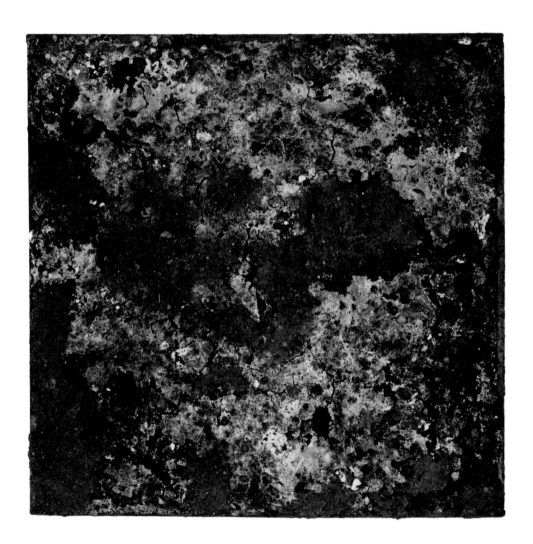

30. *Red painting* 1954
Oil paint and collage
on canvas
194.3 × 129.5
Frederick R. Weisman Art
Foundation, Los Angeles

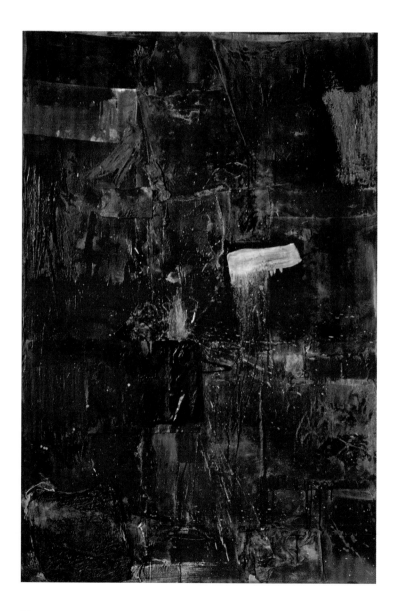

31. *Minutiae* 1954
Combine: Oil paint, paper,
fabric, newspaper, wood,
metal, and plastic with
mirror on braided wire
on wood structure
214.6 × 205.7 × 77.5
Private collection,
courtesy Hauser & Wirth

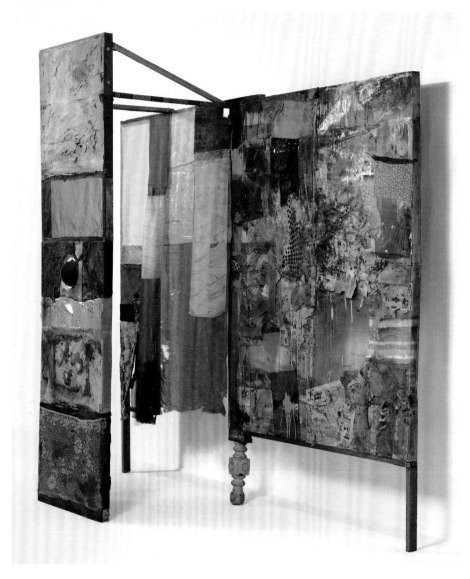

32. *Untitled* c.1954
Combine: Oil paint, pencil,
crayon, paper, canvas,
fabric, newspaper,
photographs, wood,
glass, mirror, tin, cork,
and found painting with
pair of painted leather
shoes, dried grass, and
Dominique hen on wood
structure mounted on
five casters
219.7 × 94 × 66.7
The Museum of
Contemporary Art,
Los Angeles

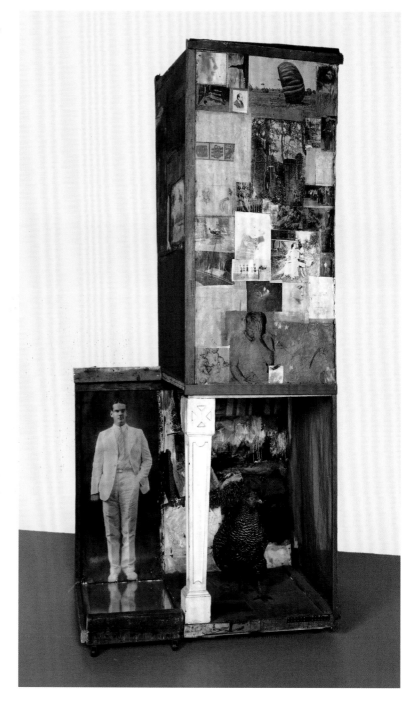

33. *Bed* 1955
Oil paint and pencil on
pillow, quilt, and sheet
on wood supports
191.1 × 80 × 20.3
Museum of Modern Art,
New York

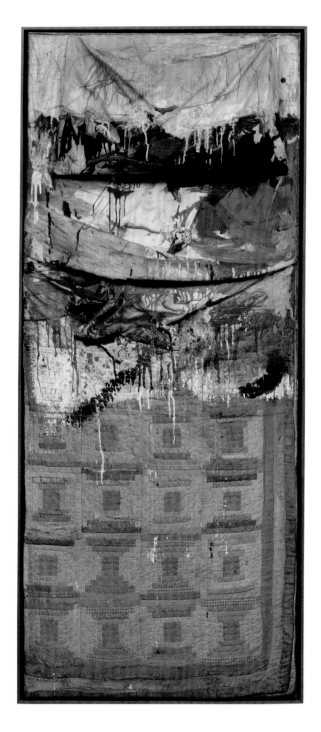

34. *Rebus* 1955
Oil paint, synthetic polymer
paint, pencil, crayon, pastel,
cut-and-pasted printed and
painted papers, and fabric on
canvas mounted and stapled
to fabric, three panels
243.8 × 333.1
Museum of Modern Art,
New York

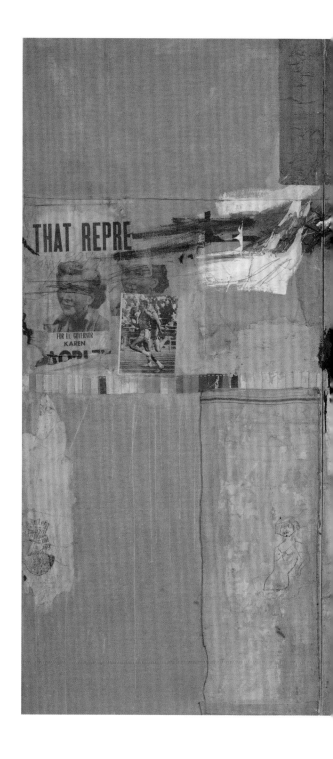

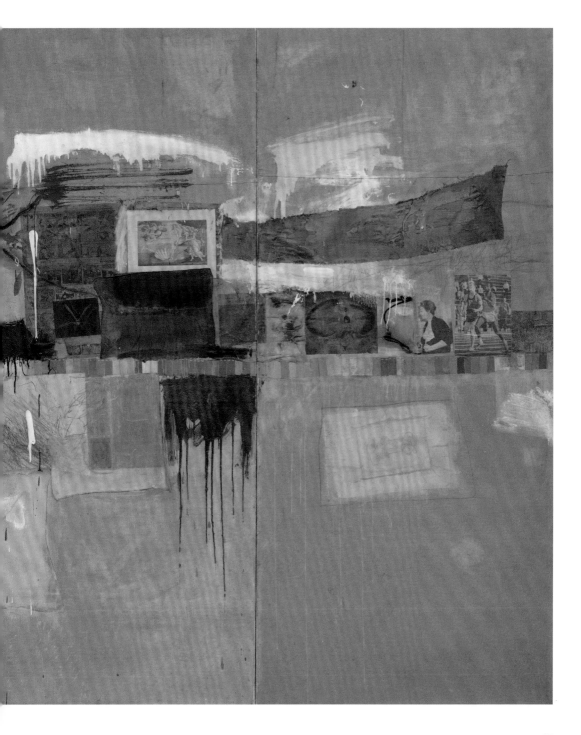

35. *Factum I* 1957
Oil paint, ink, pencil,
crayon, paper, fabric,
newspaper, printed
reproductions and painted
paper on canvas
156.2 × 90.8
The Museum of
Contemporary Art,
Los Angeles

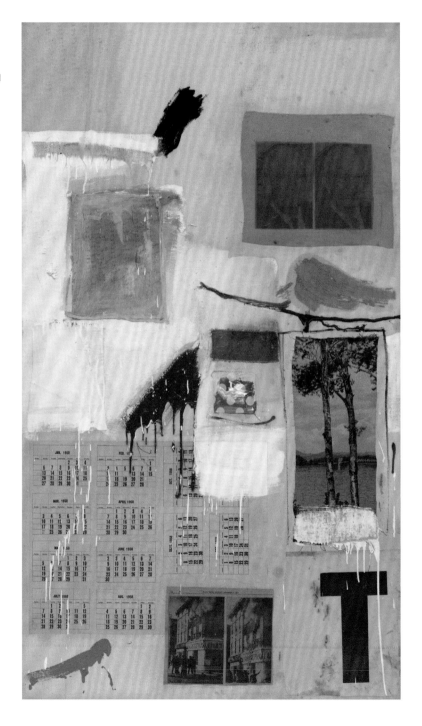

36. *Factum II* 1957
Oil paint, ink, pencil,
crayon, paper, fabric,
newspaper, printed
reproductions and painted
paper on canvas
155.9 × 90.2
Museum of Modern Art,
New York

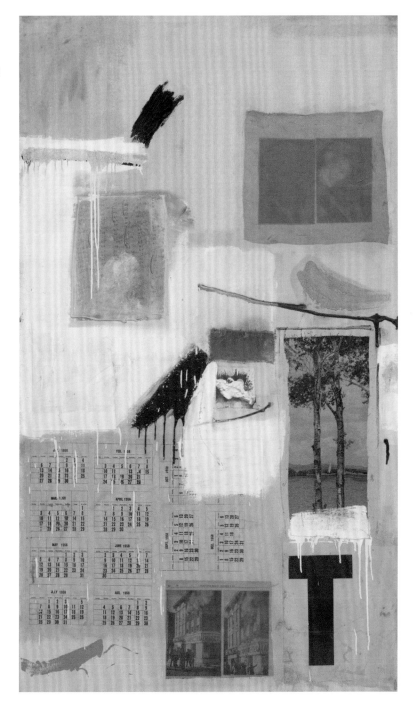

37. *Monogram* 1955–9
Oil paint on canvas, printed
paper, textile, paper, metal
sign, wood, rubber shoe
heel, tennis ball, taxidermied
angora goat with paint and
painted rubber tyre
106.5 × 160.6 × 163.5
Moderna Museet, Stockholm

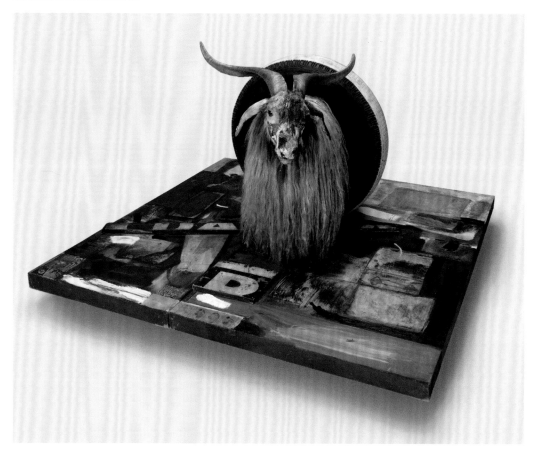

38. *Broadcast* 1959
Combine: Oil paint, graphite,
paper, fabric, newspaper,
printed paper, printed
reproductions, and plastic
comb on canvas with three
concealed radios
154.9 × 190.5 × 12.7
Ryobi Foundation

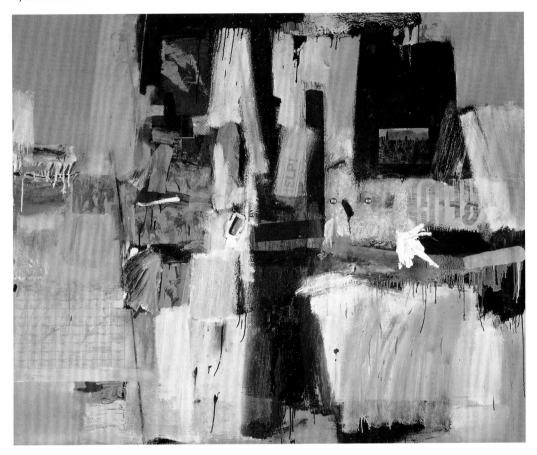

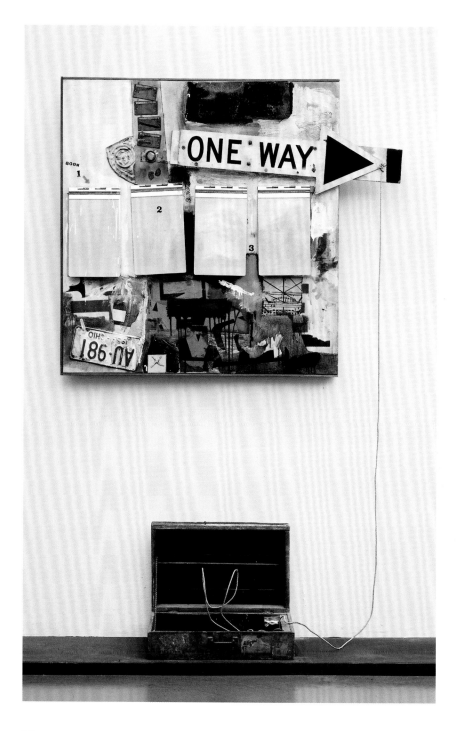

39. *Black Market* 1961
Combine: Oil paint,
watercolour, pencil, paper,
fabric, newspaper, printed
paper, printed reproductions,
wood, metal, tin, and four
metal clipboards on canvas;
with rope, rubber stamp, ink
pad, and variable objects in
wood valise randomly given
and taken by viewers
125.7 × 149.9 × 10.2
Museum Ludwig, Cologne

40. *Canto XIV: Circle Seven,*
Round 3, The Violent Against
God, Nature and Art 1960
Transfer drawing,
watercolour, gouache,
pencil, and red chalk on paper
36.7 × 29.2
Museum of Modern Art,
New York

41. *Pail for Ganymede* 1959
Combine: sheet metal and
enamel over wood with
crank, gear, sealing wax
and tin can
48.3 × 12.7. × 14 (fully
extended)
Robert Rauschenberg
Foundation

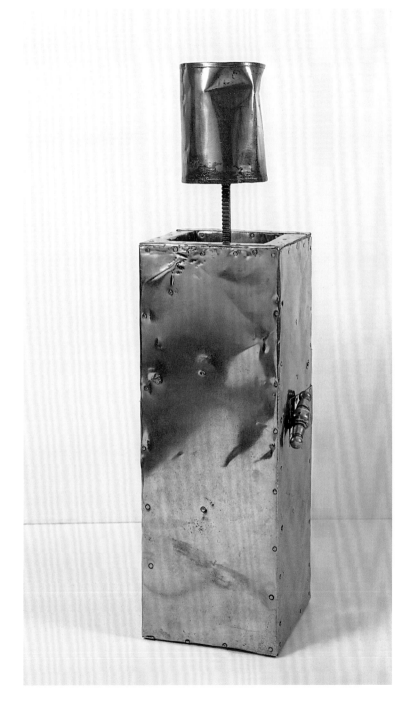

42. *Barge* 1962–3
Oil paint and silkscreen
ink on canvas
202.9 × 980.4
Guggenheim Bilbao
Museoa and Solomon
R. Guggenheim Museum,
New York

43. *Tracer* 1963
Oil and silkscreen
on canvas
213.7 × 152.4
The Nelson-Atkins
Museum of Art, Kansas
City, Missouri

44. *Retroactive II* 1964
Oil paint and silkscreen
ink on canvas
213.4 × 152.4
Museum of
Contemporary Art,
Chicago

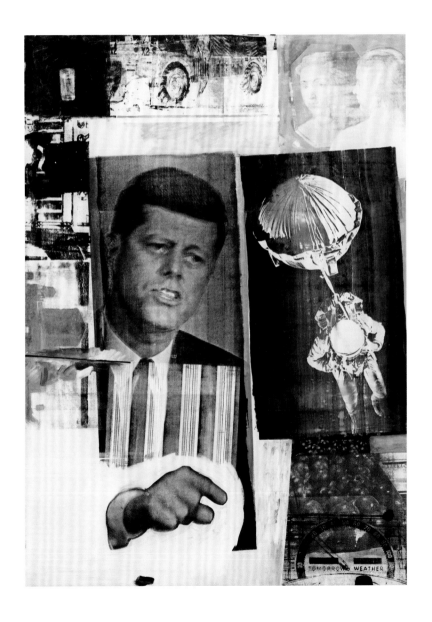

45. Peter Moore
Deborah Hay in
Rauschenberg's
Map Room II, Expanded
Cinema Festival,
December 1965

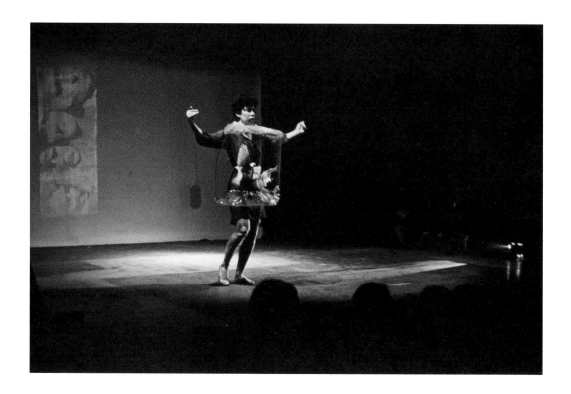

46. *Oracle* 1962–5
Five-part found-metal assemblage with five concealed radios; ventilation duct; automobile door on typewriter table, with crushed metal; ventilation duct in washtub and water, with wire basket; constructed staircase control unit housing batteries and electronic components; and wooden window frame with ventilation duct, all on wheels
Dimensions variable

Musée National d'Art Moderne, Centres Georges Pompidou, Paris

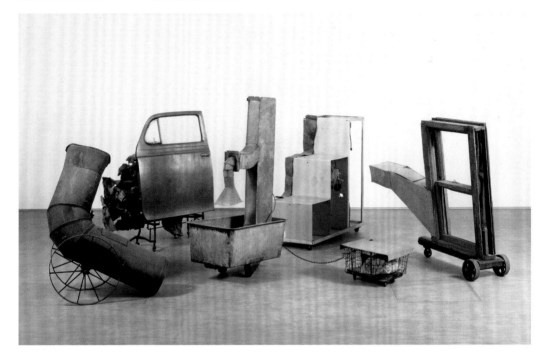

47. *Mud Muse* 1968–71
Bentonite mixed with water
in aluminium and glass
vat, with sound-activated
compressed-air system and
control console
121.9 × 274.3 × 365.8
Moderna Museet, Stockholm

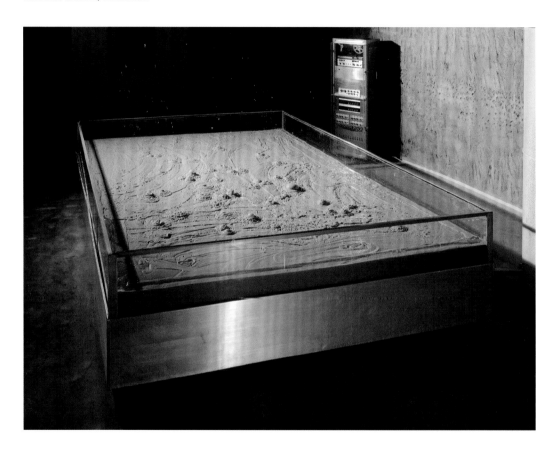

48. *Sky Rite (Stoned
Moon)* 1969
Lithograph
83.8 × 58.4
San Francisco Museum
of Modern Art

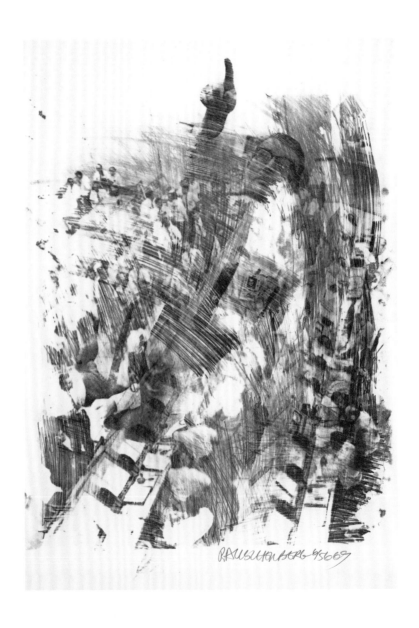

49. *Currents* 1970
Screenprint
Image 182.9 × 1625.6
Los Angeles County
Museum of Art

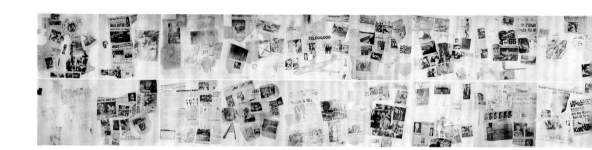

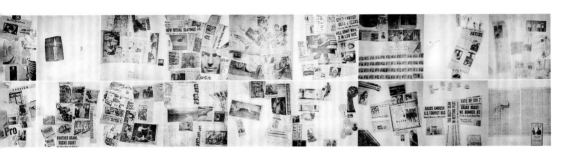

50. *Nabisco Shredded Wheat* (*Cardboard*) 1971
Cardboard
177.8 × 241.3 × 27.9
Museum of Modern Art,
New York

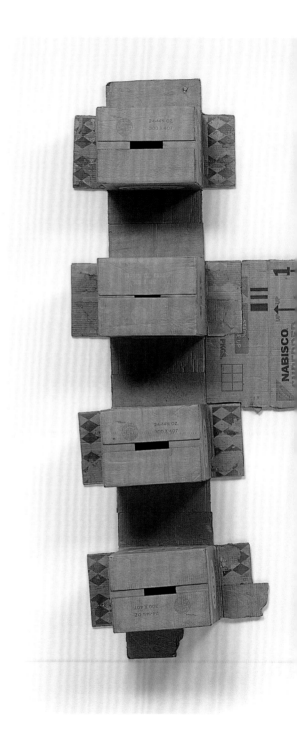

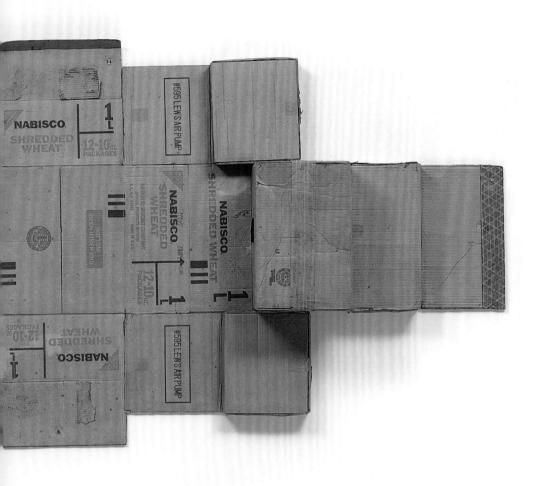

51. *Untitled* (*Jammer*) 1975
Sewn fabric with rattan
pole, twine and tin cans
254 × 91.4 × 68.6
Private collection

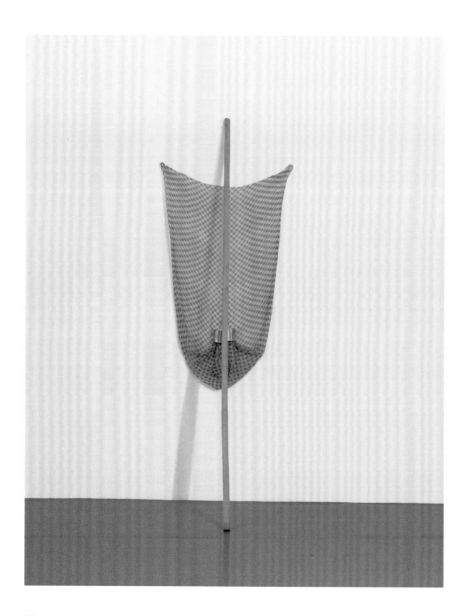

52. *Pilot* (*Jammer*) 1975
Sewn fabric, rattan pole
and string
205.7 × 215.9 × 99.1
Robert Rauschenberg
Foundation

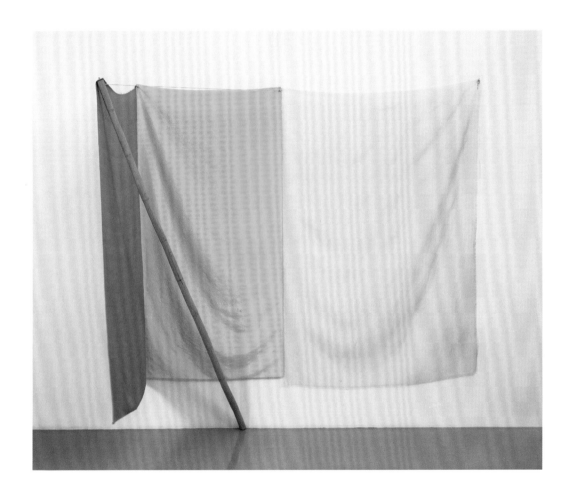

53. *Mint* (*Hoarfrost*) 1974
Ink (transfer image) on silk
and cotton, with additional
synthetic fabric, paper
and glue
198.1 × 116.6
Museum of Modern Art,
New York

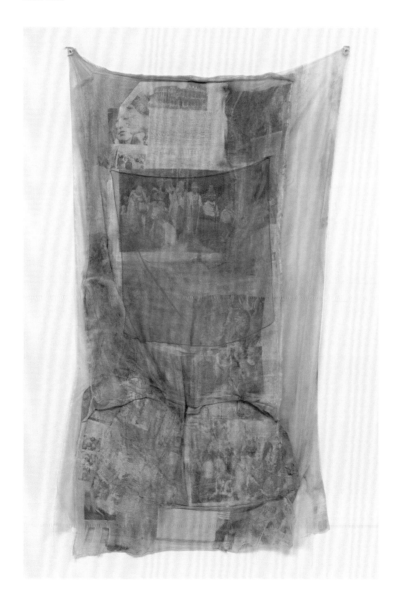

54. *Glacier* (*Hoarfrost*) 1974
Solvent transfer on satin
and chiffon with pillow
304.8 × 188 × 14.9
The Menil Collection,
Houston

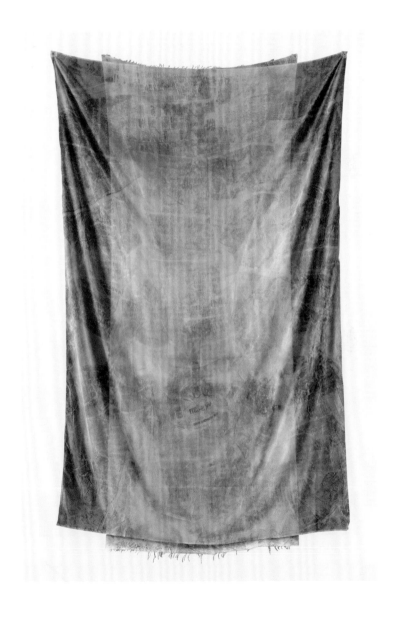

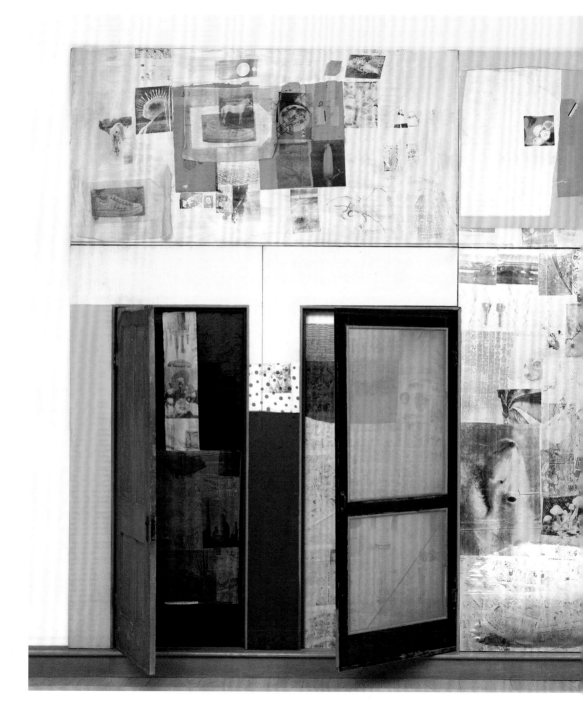

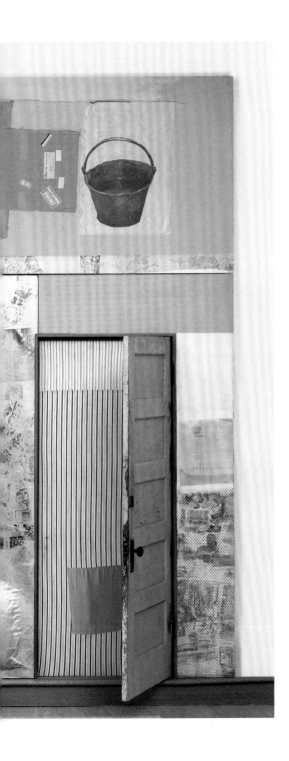

55. *Rodeo Palace
(Spread)* 1976
Solvent transfer, pencil and
ink on fabric and cardboard,
with wood doors, fabric,
metal, rope and pillow,
mounted on foamcore
and redwood supports
365.8 × 487.7 × 14
Collection of Lyn and
Norman Lear, Los Angeles

56. *The Ancient Incident*
(*Kabal American Zephyr*)
1981
Wood-and-metal stands
with wood chairs
219.7 × 233.7 × 50.8
Robert Rauschenberg
Foundation

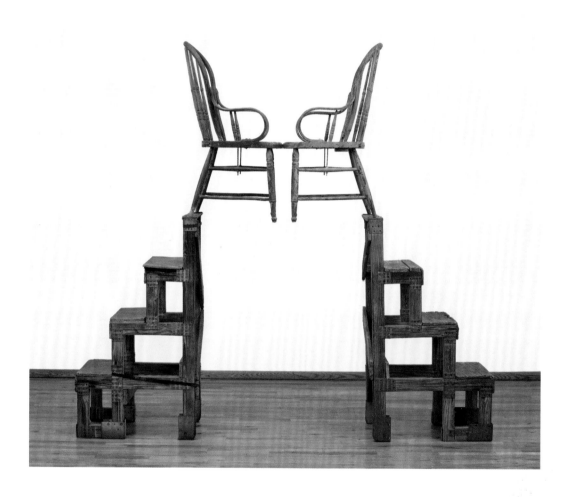

57. *Stop Side Early Winter
Glut* 1987
Metal signs and objects
109.9 × 116.8 × 86.4
Museum of Modern Art,
New York

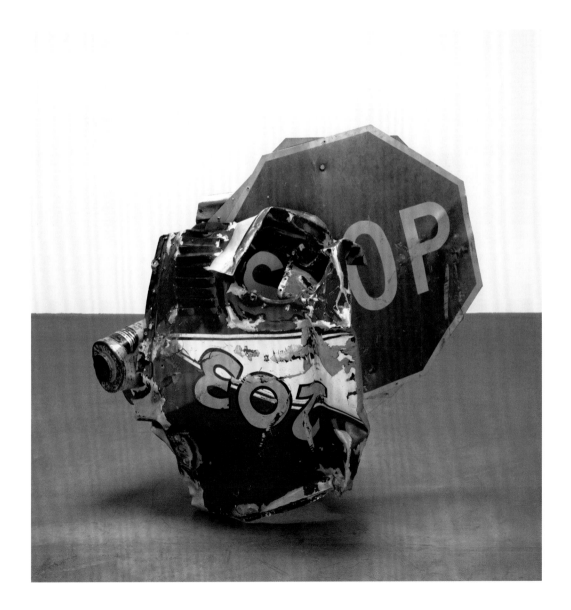

58. Exhibition poster for
ROCI CHILE 1985
Offset Lithograph on paper
87.6 × 61
From an un-numbered edition,
published by Universal Limited
Art Editions, West Islip,
New York
Robert Rauschenberg Foundation

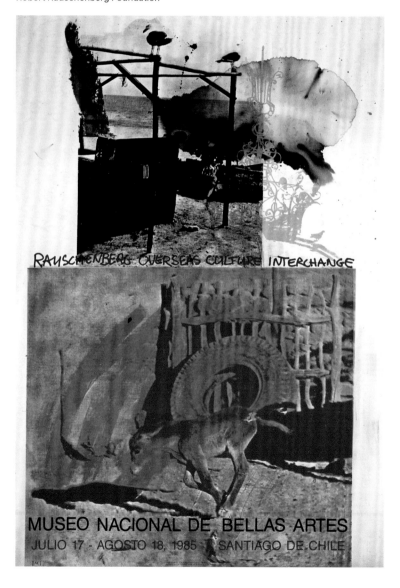

59. *Orrery* (*Borealis*) 1990
Acrylic and tarnishes on
brass with brass objects
246.4 × 459.7 × 58.4
Kunstsammlung
Nordrhein–Westfalen,
Dusseldorf

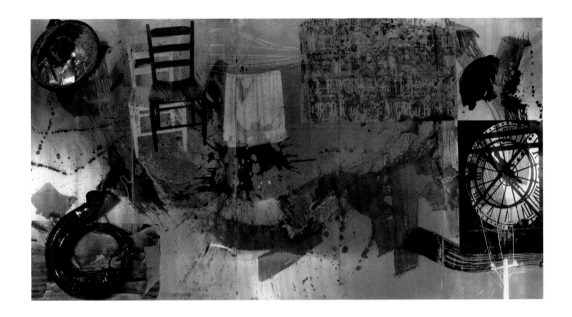

60. *Lotus IX* (*The Lotus Series*) 2008
Pigmented inkjet with
photogravure on Somerset
velvet paper,
116.2 × 152.4
From an edition of 50,
published by Universal
Limited Art Editions, West
Islip, New York
Museum of Modern Art,
New York

Notes

1. Rauschenberg in Dorothy Miller (ed.), *Sixteen Americans*, exh. cat., Museum of Modern Art, New York 1959, p.58.
2. Rauschenberg quoted by Calvin Tomkins, 'Profiles: Moving Out,' *The New Yorker*, vol.40, 29 Feb. 1964, p.59.
3. 'I was referring,' Johns remembered, 'to [Rauschenberg's] complex sense of structure, and… his constant reinvestigation of possibilities… It was a fantastically prolific conception of what art was.' Johns quoted by Calvin Tomkins, *Off the Wall: A Portrait of Robert Rauschenberg*, New York 1980 (2005 edition), p.285.
4. Rauschenberg to André Parinaud, 'Un "misfit" de la peinture new-yorkaise se confesse,' *Arts*, no.821, 10 May 1961, p.18.
5. For detailed accounts of Rauschenberg's life and work, see Tomkins, *Off the Wall*, Mary Lynn Kotz, *Rauschenberg: Art and Life*, New York 2004, and the online Chronology maintained by the Robert Rauschenberg Foundation (http://www.rauschenbergfoundation.org/artist/chronology-new).
6. Harold Rosenberg, 'The American Action Painters' (1952), in *The Tradition of the New*, New York 1959, p.25.
7. Clement Greenberg, 'American-Type Painting' (1955) in John O'Brian (ed.), *Clement Greenberg: The Collected Essays and Criticism, Volume 3, Affirmations and Refusals, 1950–1956*, Chicago and London 1993, pp.217–36.
8. John Cage, 'On Robert Rauschenberg, Artist, and His Work', *Metro*, no.2, May 1961, p.43. Cage declared the *White Paintings* a formative influence on his emblematic composition, *4'33"* (1952).
9. See Nicholas Cullinan, 'Double Exposure: Robert Rauschenberg's and Cy Twombly's Roman Holiday,' *Burlington Magazine*, vol.150, no.1264, July 2008, pp.460–70.
10. Hubert Crehan, 'The See Change: Raw Duck', *Art Digest*, vol.27, no.20, Sept. 1953, p.25.

11. *Erased de Kooning Drawing* was first exhibited at the Poindexter Gallery from 19 Dec. 1955 – 7 Jan. 1956. On the reception of the work see Sarah Roberts, 'Erased de Kooning Drawing,' *Rauschenberg Research Project*, July 2013, San Francisco Museum of Modern Art.
12. Rauschenberg in 'Robert Rauschenberg talks to Maxime de la Falaise McKendry,' *Interview*, vol.6, no.5, May 1976, p.36.
13. Rauschenberg in Tomkins 1964, p.72.
14. Stuart Preston, 'Divisions of Today', *The New York Times*, 19 Dec. 1954, Section 2, p.12. The only positive review was written by the poet Frank O'Hara: 'Reviews and Previews: Bob Rauschenberg', *ArtNews*, Jan.1955, p.47.
15. *Rebus* was first 'decoded' by Charles F. Stuckey, in 'Reading Rauschenberg', *Art in America*, vol.65, no.2, March-April 1977, pp.74–84. For a fascinating debate on these issues, see Thomas Crow, 'Rise and Fall: Theme and Idea in the Combines of Robert Rauschenberg,' in Paul Schimmel (ed.), *Robert Rauschenberg: Combines*, Los Angeles 2005, pp.231–56; and Yve-Alain Bois, 'Eye to the Ground,' *Artforum*, vol.44, no.7, March 2006, pp.244–8, 317. Talking to Dorothy Gees Seckler in December 1965, Rauschenberg himself declared, 'If I see any superficial subconscious relationships that I'm familiar with – clichés of association – I change the picture. I always have a good reason for taking something out but never have one for putting something in. I don't want to – because that means that the picture is being painted pre-digested.' Rauschenberg to Dorothy Gees Seckler, 'The Artist Speaks: Robert Rauschenberg', *Art in America*, vol.54, no.3, May-June 1966, p.76.
16. See Alex Potts, *Experiments in Modern Realism: World Making in Postwar European and American Art*, New Haven and London 2013, pp.267ff.

17. Hilton Kramer, 'Month in Review, *Arts*, vol.33, no.5, Feb. 1959, pp.49–50.
18. Jack Kroll, 'Reviews and Previews: Robert Rauschenberg', *ARTnews* vol.60, no.8, Dec. 1961, p.12.
19. See, for example, Jonathan Katz, 'The Art of Code', in Whitney Chadwick and Isabelle de Courtivron (eds), *Significant Others, Creativity and Intimate Partnership*, London 1993, pp.189–208.
20. See, for example, Helen Molesworth, 'Before Bed', *October* 63, Winter 1993, pp.68–82.
21. On *Monogram*, see, for example, Hiroko Ikegami, *The Great Migrator: Robert Rauschenberg and the Global Rise of American Art*, Cambridge, MA and London 2010, pp.116ff, and Leo Steinberg, *Encounters with Rauschenberg, A Lavishly Illustrated Lecture*, Houston and Chicago 2000, pp.54ff.
22. Kenneth Bendiner, 'Robert Rauschenberg's "Canyon",' *Arts Magazine*, vol.56, no.10, June 1982, pp.57–9.
23. Not reading Italian, Rauschenberg referred primarily to John Ciardi's recently published translation: Dante Alighieri, *The Inferno*, trans. John Ciardi, New York 1954.
24. See Rosalind Krauss, 'Perpetual Inventory', in Walter Hopps and Susan Davidson (eds.), *Robert Rauschenberg. A Retrospective*, New York 1997, pp.206–23.
25. Leo Steinberg, 'Reflections on the State of Criticism,' *Artforum*, vol.10, no.7, March 1972, pp.47–9.
26. See, for example, Brian O'Doherty, 'Robert Rauschenberg,' *The New York Times*, April 28, 1963, Section 2, p.13; and Max Kozloff, 'Art,' *The Nation*, vol.197, no.19, 7 Dec. 1963, pp.402–3.
27. See Ikegami 2010.
28. Erica Abeel, 'Daedalus at the Rollerdrome,' *Saturday Review*, 28 Aug. 1965, p.53.
29. Branden Joseph, *Random Order – Robert Rauschenberg and the Neo-Avant-Garde*, Cambridge, MA and London 2003, p.227.

30. Rauschenberg to Barbara Rose, *Rauschenberg*, New York 1987, p.65ff.
31. Rauschenberg quoted in *Robert Rauschenberg – Transfer Drawings from the 1960s*, New York 2007, p.46.
32. See Yve-Alain Bois, 'Pause,' in Yve-Alain Bois, Clare Elliott, and Josef Helfenstein, *Robert Rauschenberg: Cardboards and Related Pieces*, New Haven and London 2007, pp.17–27.
33. Rauschenberg reported by Tomkins in an undated interview conducted in preparation for *Off the Wall*. Calvin Tomkins Papers, The Museum of Modern Art Archives, New York (Series IV.C, folder 45).
34. Hopps later recalled reasoning to Joshua Taylor, then director of the museum, 'What you want is an artist who is also a great citizen, who is engaged in the political dialogue and discourse, takes public stands, is a benefactor and philanthropist, who believes not only in his own art, but in the fate and lives of other artists, and has invested in them.' Hopps quoted by Mary Lynn Kotz, *Rauschenberg / Art and Life*, New York 1990, p.210.
35. In a statement written in 1984, Rauschenberg explained, 'I feel strong in my beliefs, based on my varied and widely traveled collaborations, that a one-to-one contact through art contains potent peaceful powers, and is the most non-elitist way to share exotic and common information, seducing us into creative mutual understandings for the benefit of all. Art is educating, provocative, and enlightening even when first not understood. The very creative confusion stimulates curiosity and growth, leading to trust and tolerance. To share our intimate eccentricities proudly will bring us all closer.' Rauschenberg, 'Tobago Statement,' in *Rauschenberg Overseas Culture Interchange*, exh. cat., Washington, D.C.: National Gallery of Art, 1991, p.154
36. On Rauschenberg's collaborations with ULAE, see Mimi Thompson, *Robert Rauschenberg Prints from Universal Limited Art Editions, 1962–2008*, Norman, Oklahoma, 2011.

Index

A

Abeel, Erica 22
abstract expressionism 5, 7–9, 12, 14, 16
Académie Julian 7
action painting 14
Albers, Josef 7
The Ancient Incident (Kabal American Zephyr) fig.56
Apollo moon landings 24; fig.48
Art Students League 7
arte povera 25

B

Barge fig.42
Bauhaus 7
Bed 17; figs.1, 33
Bendiner, Kenneth 17
Black Market fig.39
Black Mountain College 7, 9, 11
Black Paintings series 11; fig.24
Blueprint series 9; fig.21
Bois, Yve-Alain 25
Borealis series 26; fig.59
Broadcast 23; fig.38

C

Cage, John 7, 9, 22; fig.17
Canto XIV fig.40
Canyon 17; fig.10
Captiva 24
Cardboard series 25; fig.50
Charlene 14; fig.8
civil rights movement 24
Cold War 24
collage 5, 9, 14
Collection 14
Combines 5, 14–15, 25; figs.1, 8, 14
Crehan, Hubert 11
cubism 9
Cunningham, Merce 7, 22; fig.17
Currents 24, 25; fig.49
Cy + Roman Steps (I–V) fig.27

D

Dante
Inferno 18, 25
de Kooning, Elaine 7
de Kooning, Willem 7, 12–13
Pictures on the Theme of the Woman 10–11
Woman II fig.5
Dirt Painting (For John Cage) 11; fig.29
Duchamp, Marcel
L.H.O.O.Q 12

E

Elemental Paintings 11
Elemental Sculptures fig.6
Erased de Kooning Drawing 12–13; fig.7
exhibitions
1951 Betty Parsons Gallery 9
1953 de Kooning, *Pictures on the Theme of the Woman* 10–11
1953 Stable Gallery 11; fig.6
1954 Charles Egan Gallery 14
1959 *Sixteen Americans* 21
1963–4 retrospective 21
1964 Venice Biennale 21; fig.16
1968 Leo Steinberg Gallery 20
1976 retrospective 26
Documenta 2 21
ROCI 26–7; fig.58
Experiments in Art and Technology 23
Express fig.16

F

Factum I fig.35
Factum II fig.36
Fuller, Buckminster 7

G

Gainsborough, Thomas 7
Glacier (Hoarfrost) 25; fig.54
Glut series 26; fig.57
Greenberg, Clement 8–9, 20

H

Hay, Alex 23
Hay, Deborah 22–3; fig.45
Hoarfrost series 25; figs.53, 54
Hopps, Walter 26

I

Interview fig.1

J

Jammer series 25; figs.51, 52
Johns, Jasper 5, 14; fig.9
Joseph, Branden 23
Judson Dance Theatre 22

K

Kansas City Art Institute 7
Katz, Jonathan 16
Kline, Franz 7
Klüver, Billy 23
Kramer, Hilton 16
Kroll, Jack 16

L

Lawrence, Thomas 7
22 The Lily White fig.22
Lotus series 27; fig.60

M

Map Room II 22–3; fig.45
minimalism 25
Mint (Hoarfrost) 25; fig.53
Minutiae fig.31
modernism 8, 9, 20
Monogram 17; figs.1, 37
Mud Muse 23; fig.47

N

Nabisco Shredded Wheat (Cardboard) 25; fig.50
neo-avant-garde 12
New York 7
Newman, Barnett 7

O

Odalisk fig.1
Oracle 23; fig.46
Orrery (Borealis) 26; fig.59

P

Pail for Ganymede 17; fig.41
Paris 7
Parsons, Betty 9
Paxton, Steve 23
Pelican 22; fig.18
performance works 5, 22–3; figs.18, 45
photographic imagery 5, 9, 18, 19, 24–5; figs.12–14
Picasso, Pablo 5
Pilot (Jammer) 25; fig.52
Pollock, Jackson 7, 8–9, 13
Number 1 fig.3
One: Number 31 fig.3
Pop Art 5, 25
post-modernism 20
Preston, Stuart 14

R

Rainer, Yvonne 23
Rauschenberg, Christopher (son) 9, 17
Rauschenberg, Robert figs.1, 2, 4, 6, 14, 17, 18, 26
birth and family 6
death 27
dyslexia 6–7
education 7
marriage 9
sexuality 14–15
U.S. Navy 7; fig.2

Rauschenberg Overseas Culture Interchange (ROCI) 26–7; figs.20, 58
Rebus 14; fig.34
Red painting fig.30
Rembrandt van Rijn
The Rape of Ganymede 17; fig.11
Retroactive II fig.44
Revolvers 23; fig.19
Rodeo Palace (Spread) 26; fig.55
Rosenberg, Harold 8

S

Scanning 20; fig.15
Scatole Personali series 10; fig.26
set designs 5, 22
silkscreen 5, 19; figs.14, 15, 42–4
Sky Rite (Stoned Moon) 24; fig.48
Skyway 19; fig.14
solvent transfer technique 9–10, 18, 25; figs.4, 12, 53–5
Spread series 26; fig.55
Steinberg, Leo 20–1
Stop Side Early Winter Glut 26; fig.57
surrealism 9

T

Thirty-Four Illustrations for Dante's Inferno 18, 25; fig.12
Tomkins, Calvin 12–13, 25
Tracer fig.43
Twombly, Cy 9, 10

U

Untitled (1951) 11; fig.24
Untitled (1954) fig.1
Untitled (double Rauschenberg) (with Weil) 9; fig.21
Untitled (Gold Painting) 11; frontispiece; fig.28
Untitled (Jammer) 25; fig.51
Untitled (Mirror) fig.25
Untitled (Plymouth Rock) fig.32
Untitled (Scatole Personali series) 10; fig.26

V

Vietnam War 24

W

Waldhauer, Fred 23
Warhol, Andy 19
Brillo Boxes 25
Weil, Susan 7, 9
Untitled (double Rauschenberg) (with Rauschenberg) 9; fig.21
White Paintings series 9; figs.6, 23
Whitman, Robert 23

First published 2016 by order of the Tate Trustees by
Tate Publishing, a division of Tate Enterprises Ltd,
Millbank, London SW1P 4RG
www.tate.org.uk/publishing

© Tate Enterprises Ltd 2016

A catalogue record for this book is available from
the British Library

ISBN 978 1 84976 489 6

Distributed in the United States and Canada by
ABRAMS, New York

Library of Congress Number applied for

Designed by Anne Odling-Smee, O-SB Design
Colour reproduction by DL Imaging Ltd, London
Printed in and bound by Graphicom SRL, Italy

Cover: *Charlene* 1954 (detail of fig.0)
Frontispiece: *Untitled (Gold Painting)* c.1953 (detail of
fig.28)

Measurements of artworks are given in centimetres,
height before width.

Copyright credits

All works © Robert Rauschenberg Foundation,
with the exception of the following:

Photo © Douglas Jeffery/ Victoria and Albert
Museum, London fig.17

Photo © Jasper Johns/ VAGA, New York/ DACS,
London 2016 fig.4

© 2016 The Willem de Kooning Foundation/
Artists Rights Society (ARS), New York and DACS,
London 2016 fig.5

Digital image courtesy Robert Rauschenberg
Foundation Archives, New York. © Barbara Moore/
Licensed by VAGA, New York, NY. Courtesy Paula
Cooper, New York figs.18, 45

Photo © Ugo Mulas Heirs fig.16

Photo © 2016 Hans Namuth Estate figs.3, 14

© The Pollock-Krasner Foundation ARS, NY and
DACS, London 2016 fig.3

Photo credits

bpk | Staatliche Kunstsammlungen Dresden |
Hans-Peter Klut fig.11

Ben Blackwell figs.7, 15

Thomas Buehler fig.20

James Burke/ The LIFE Picture Collection/ Getty
Images fig.13

Courtesy Center for Creative Photography,
University of Arizona figs.3, 14

© Centre Pompidou, MNAM-CCI, Dist. RMN-
Grand Palais/ Droits reserves fig.46

Allan Grant/ The LIFE Picture Collection/ Getty
Images fig.6

Kay Harris fig.1

Hickey-Robertson, Houston fig.54

Nathan Keay © MCA Chicago fig.44

© 2016 Museum Associates/ LACMA/ Art
Resource NY/ Scala, Florence fig.49

Light Blue Studio, courtesy Craig F. Starr Gallery
figs.26, 28, frontispiece

Rob McKeever, courtesy Gagosian Gallery fig.51

© 2016 Museum of Modern Art, New York/Scala,
Florence figs.5, 10, 12, 25, 33, 34, 36, 40, 50,
53, 57

Don Ross figs.27, 48

Moderna Museet, Stockholm figs.37, 47

© Victoria and Albert Museum, London fig.17